How Artists See
FEELINGS
Joy Sadness Fear Love

Colleen Carroll

ABBEVILLE KIDS

A DIVISION OF ABBEVILLE PUBLISHING GROUP

New York London

*"Painters understand nature and love her
and teach us to see her."*

—VINCENT VAN GOGH

––––––––

For my "baby angel," Juliet Claire.
Thank you for the love and joy you bring to me every day.

Thank you to the many people who helped me with yet
another volume, especially Kerrie Baldwin, Jacqueline Decter,
Patricia Fabricant, Colleen Mohyde, Justyna Swierk,
and, as always, my husband, Mitch Semel.

— COLLEEN CARROLL

JACKET AND COVER FRONT: Edvard Munch,
The Scream, 1893 (see also pp. 26-27).
JACKET AND COVER BACK, LEFT:
Jean-Honoré Fragonard, *The Swing,* c. 1767
(see also pp. 8–9);
RIGHT: Masaccio, *Expulsion from the Garden,*
c. 1427 (see also pp. 12–13);
JACKET BACK, BOTTOM: Mary Cassatt, *Under the
Horse Chestnut Tree,* 1898 (see also pp. 32–33).

EDITORS: Kerrie Baldwin and Jacqueline Decter
DESIGNER: Patricia Fabricant
PRODUCTION MANAGER: Maria Pia Gramaglia

Text copyright © 2001 Colleen Carroll.
Compilation, including selection of text and
images, copyright © 2001 Abbeville Press. All
rights reserved under international copyright
conventions. No part of this book may be repro-
duced or utilized in any form or by any means,
electronic or mechanical, including photocopy-
ing, recording, or by any information storage
and retrieval system, without permission in
writing from the publisher. Inquiries should be
addressed to Abbeville Publishing Group, 137
Varick Street, New York, NY 10013. The text of
this book was set in Stempel Schneidler.
Printed and bound in China.

First library edition
10 9 8 7 6 5 4
ISBN-13: 978-0-7892-0616-9
ISBN-10: 0-7892-0616-1

Library of Congress Cataloging-in-Publication Data
Carroll, Colleen
 Feelings: joy, sadness, fear, love /
Colleen Carroll.
 p. cm.—(How artists see)
 Includes bibliographical references.
 ISBN 0-7892-0616-1 (alk. paper)
 1. Emotions in art—Juvenile literature. 2. Art
appreciation—Juvenile literature. [1. Emotions in
art. 2. Art appreciation.] I. Title.
N8217.E53 C37 2001
701'.15—dc21 2001022968

For bulk and premium sales and for text adoption
procedures, write to Customer Service Manager,
Abbeville Press, 137 Varick Street, New York, NY
10013, or call 1-800-ARTBOOK.

Visit Abbeville Press online at www.abbeville.com.

CONTENTS

LAUGHING BOY

by Desiderio da Settignano

Everyone has feelings. They're as natural as breathing the air. Artists, who are particularly sensitive to the world around them, are experts at showing what it's like to feel the emotions that we all experience. In this book, you'll discover how artists portray four very different feelings: joy, sadness, fear, and love. Some of the artworks may remind you of feelings you have had now and then.

Joy is one of the most, well, joyous of emotions. To experience joy is one of the great gifts of being human. In this sculpture of a little boy, the artist has captured the feeling of pure glee. Although made of stone, the boy's happiness seems almost real. How does the artist convey his joyfulness? What do you think could be making him laugh so hard? Close your eyes and try to imagine the sound of his laughter. What do you hear?

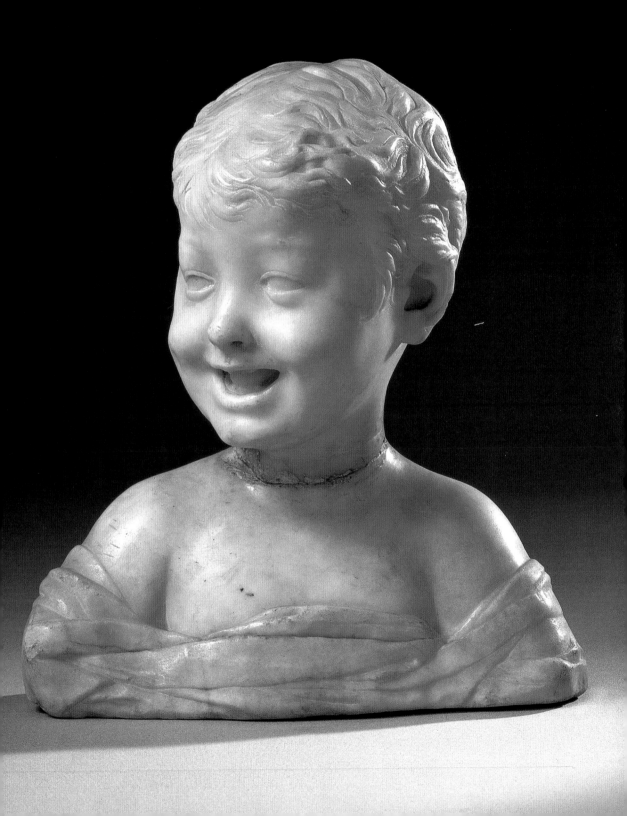

LE MOULIN DE LA GALETTE

by Pierre-Auguste Renoir

It would be hard to find a long face in this crowd of people, who are happily dancing and talking at an outdoor dance hall in France. Point to all the smiling faces you can find. As these people enjoy themselves, a dappling of soft light falls on the space, illuminating faces and creating patches of gold on clothing and on

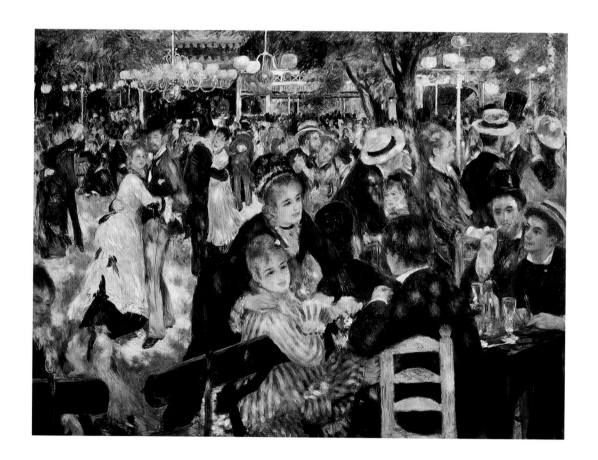

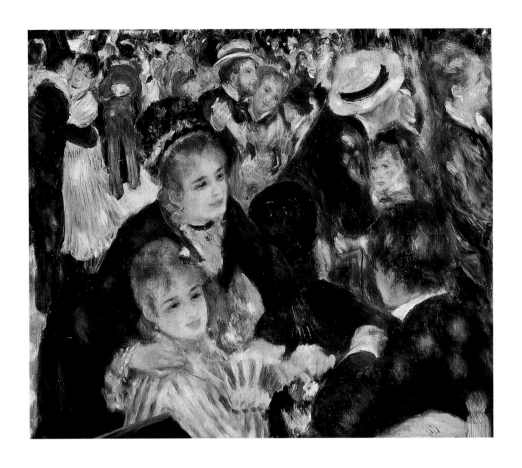

the dance floor. Does this warm, yellow light help to create a joyous atmosphere? How?

To give the scene a feeling of great activity, the artist filled the painting with many people. How do they interact with one another? The canvas is divided into three sections: the front, the middle, and the back. Starting in the front let your eyes travel all the way to the background. What cheerful activities do you see along the way? How would the picture look if there weren't as many people in it? If you were part of this cheerful crowd, what would you be doing?

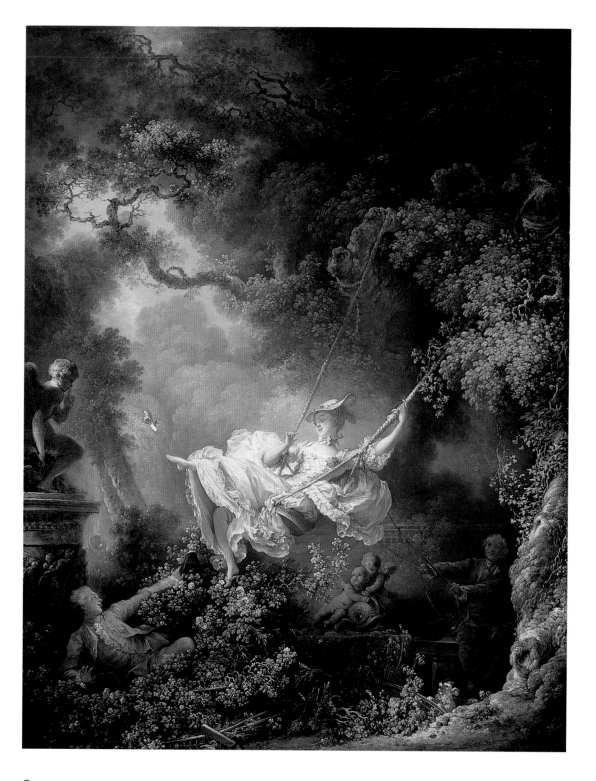

THE SWING

by Jean-Honoré Fragonard

The young lady in this picture is clearly having a good time as her swing soars into the air. To express her delight, she has kicked off her shoe. Can you find it? In what other ways has the artist conveyed her feelings? What feelings do you have when you are swinging?

Here there is actually a pair of young lovers enjoying themselves on a beautiful, sunny day. But it's the lady that the artist wants you to pay the most attention to, so he placed her in the center of the picture. What other things do you see that draw your eye to her? Why do you think the artist wants you to focus on her more than on other parts of the picture?

9

RISE, SHINE FOR THY LIGHT HAS COME

by Aaron Douglas

Have you ever felt so happy that you could sing? That's what you see here, in this painting of a woman lifting her voice in praise. As she looks up toward the heavens, a triangle of light blue points into her eyes. What do you think this triangle of color could be? The artist included words in his picture, too—perhaps they are the lyrics to this joyful song. What other musical elements do you see?

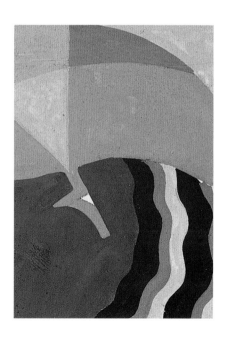

Instead of making a picture with many different colors, the artist chose to use only a few: blue, black, and white. How many different shades of blue do you see? Why do you think the artist picked this color to express happiness? If you were making a picture that showed a joyous feeling, what colors would you use?

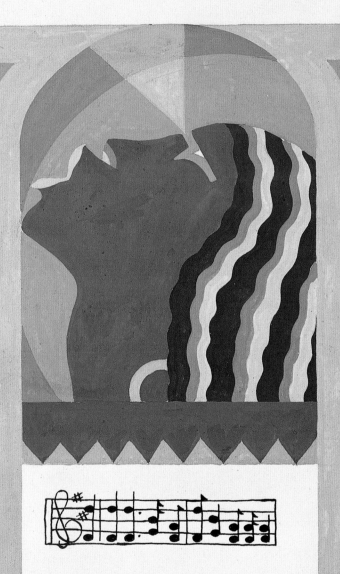

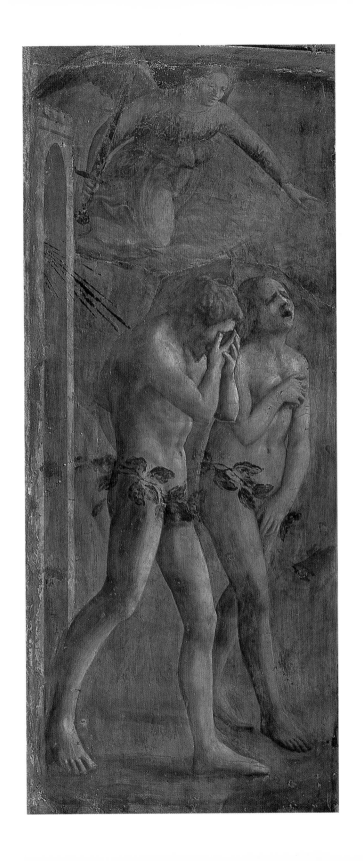

12

EXPULSION FROM THE GARDEN

by Masaccio

Although it's not a pleasant emotion, sadness is felt by all people at some time in life. Without sadness it would be impossible to truly appreciate joy. This picture depicts one of the saddest stories ever told: Adam and Eve being ordered out of the Garden of Eden. The couple leaves the garden through an arched gateway and ventures into a harsh, new world. How has the artist expressed their deep despair? Compare the angel's face with the faces of Adam and Eve. Why do you think the artist made the angel so beautiful compared to the anguished pair of people?

And even if you wanted to rest your eyes on something not quite so sad, the artist won't let you! By making a picture with very little in the background except a dry, barren desert, he made sure you would concentrate on these unhappy people and what they are feeling. Even the angel hovering above them looks downward, bringing your eyes back to the mournful pair. What other emotions do you feel when looking at this picture?

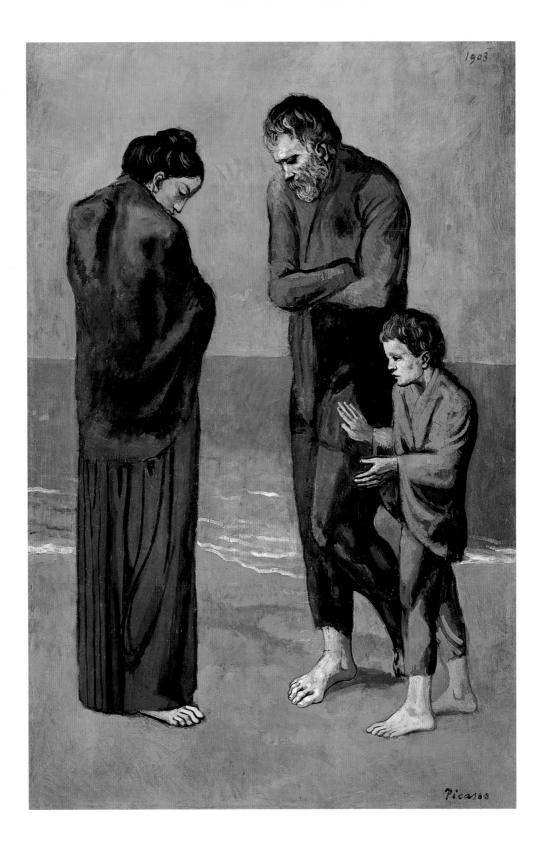

THE TRAGEDY

by Pablo Picasso

A tragedy is a very sad, disastrous event. What do you think has happened to this family to make them so sad? One way the artist captured their immense sadness is by showing them with their heads lowered. And although they are standing together, they seem to be very separate from one another, like three statues on an empty beach. Only the little boy shows any sign of movement, as he gently touches the man's leg with one hand and gestures with the other. What does the boy seem to be doing here? How else does the artist convey their emotions?

Like the picture you just saw that showed a very joyous person, this painting, too, uses only the colors blue, black and white. But in this one, the blue shades give the picture a feeling of melancholy. Artists often use cool colors, such as blue and purple, to convey sadness. When looking at this picture, do you feel blue?

THE LAMENTATION: IN MEMORY OF ERNST BARLACH

by Käthe Kollwitz

There is nothing quite so sorrowful as the loss of a loved one. In this self-portrait, the artist expresses her deep sadness at the death of one of her closest friends. Consumed with grief, her face seems to be encased in the bronze, as if she were sinking deep into it. How does the heaviness of the metal help show her feelings? In what other ways does the artist convey her anguish?

Look back at *Expulsion from the Garden.* Although it is a fresco painted on a wall, it has many things in common with this sculpture. For example, both artists keep the action up front: there is no background to look at. In what other ways are these two artworks similar? How are they different?

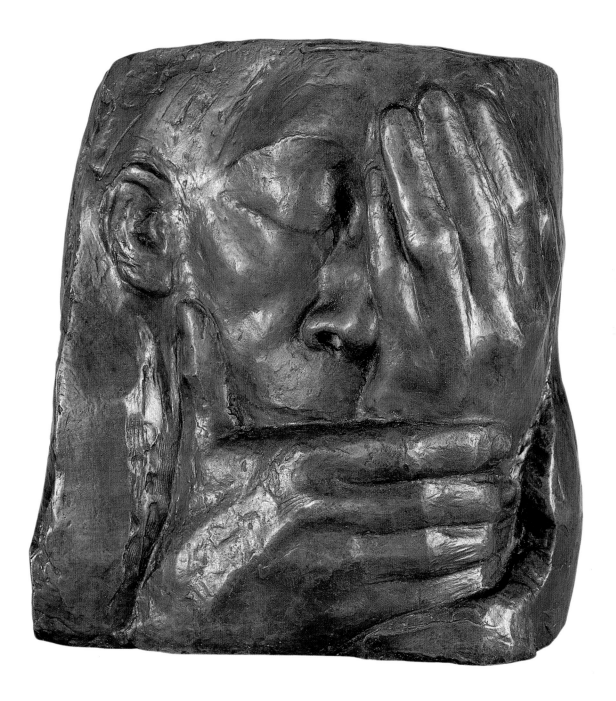

17

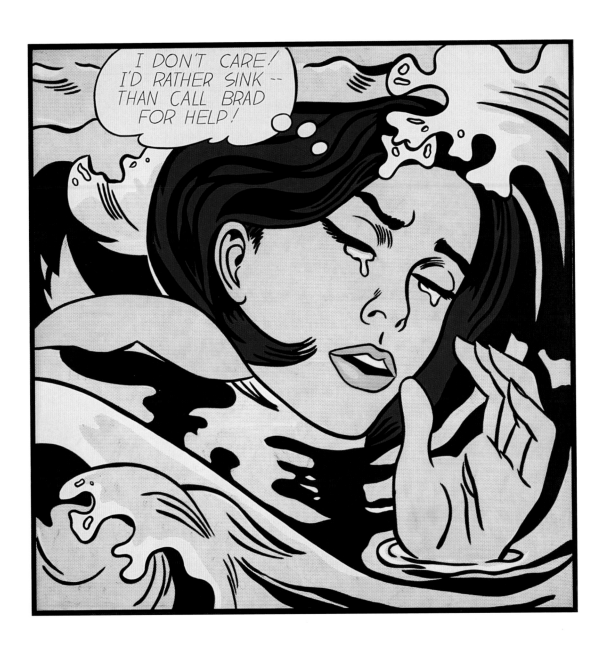

DROWNING GIRL

by Roy Lichtenstein

Have you ever cried so much that you could have "drowned in your own tears"? Of course, people can't actually drown in tears, yet the woman you see here seems to be doing just that. To exaggerate her feelings of despair, the artist uses bold, swirling waves of lines that engulf the woman, leaving only her head and left hand above the surface of her tears. Now compare this picture to the sculpture you just saw. In which picture does the woman look sadder?

I DON'T CARE! I'D RATHER SINK -- THAN CALL BRAD FOR HELP!

The artist made his painting in the style of comic books, using bold colors, black outlines, and tiny Benday dots. And like comics, he used words to help express the woman's emotions. Read her thoughts in the bubble floating at the top of the picture. What could Brad have done to make this woman so sad? How does her comic-book appearance affect your feelings for her? The actual painting is more than five feet high and five feet wide. How does the picture's size affect your feelings for the woman and the situation she is in?

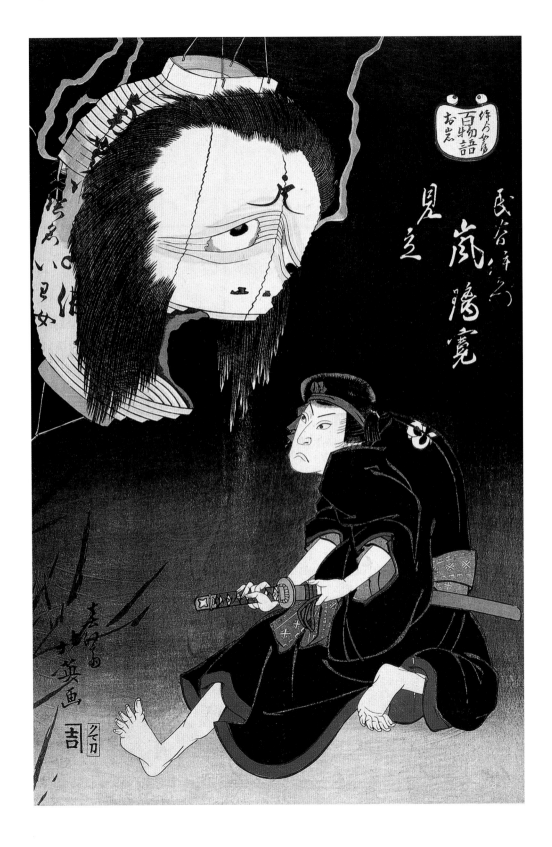

LEMON AND HIS WIFE'S GHOST

Shunbaisai Hokuei

Did you know that all people have fears? Even the bravest person you can think of is afraid of something. In this picture, an actor on a stage spins around to face the ghost that has appeared behind him. Point to its eerie face. The specter floats in the lantern and a spooky wail seems to be coming from its open mouth.

What do you think it sounds like? The man is unsheathing his sword to protect himself from this ghost. How else has the artist conveyed the man's fear?

As you have seen earlier, some artists use many colors and some only use a few. In this picture, there are practically no colors at all, mostly black and white. Why do you think he used these two tones more than the other colors? How does the stark contrast of black against white help make this scene a scary one to behold?

TORNADO OVER KANSAS

by John Steuart Curry

The awesome power of nature can be a deeply fright-
ening thing. Here, a family runs for shelter from a quickly
approaching tornado. As they dash toward the storm
cellar, the funnel rages across the horizon and causes
explosive damage at its base. The murky grays, purples,
and blues of the sky cast an ominous light over the land.
What other frightening elements does the artist include
to create a feeling of suspense? Try to imagine yourself
in this situation. What sounds do you hear?

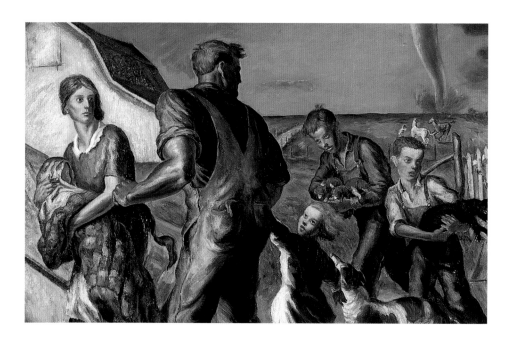

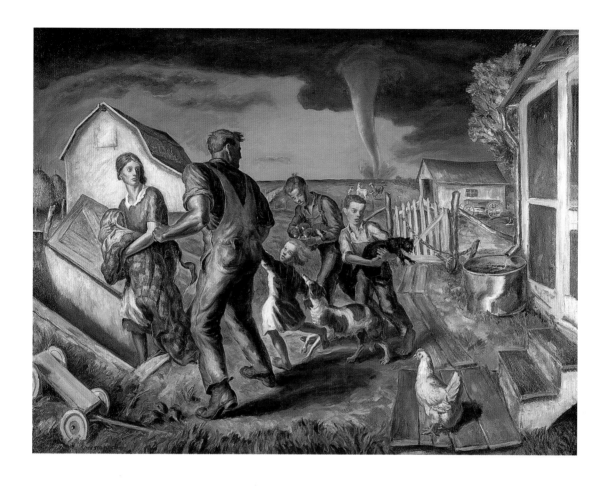

The artist makes the picture look very real to help you to feel the fear the family is experiencing. Look at the expressions on their faces. What do you think each person is feeling at this moment? Although you cannot see the father's face, almost everyone in the family looks directly at him. Do you think he's afraid? Look in the mirror and try to re-create what you imagine his expression to be.

WATSON AND THE SHARK

by John Singleton Copley

Most people would agree that no creature on earth is more terrifying than the shark. Like *Tornado Over Kansas,* this picture captures a situation at its most frightening moment. You can almost hear the slapping of the waves, the people screaming, and the sound of the harpoon as it punctures the shark's leathery flesh. As the shark moves in toward its prey, the unfortunate swimmer, Watson, will be either pulled to safety or devoured by the powerful fish. What do you think will happen?

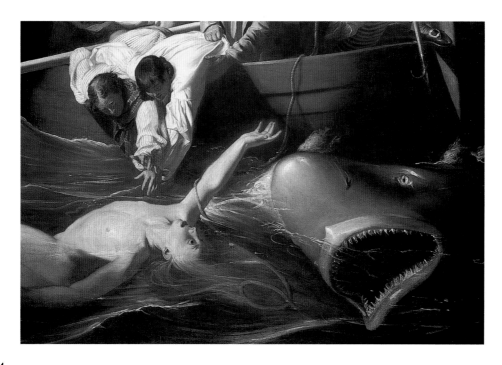

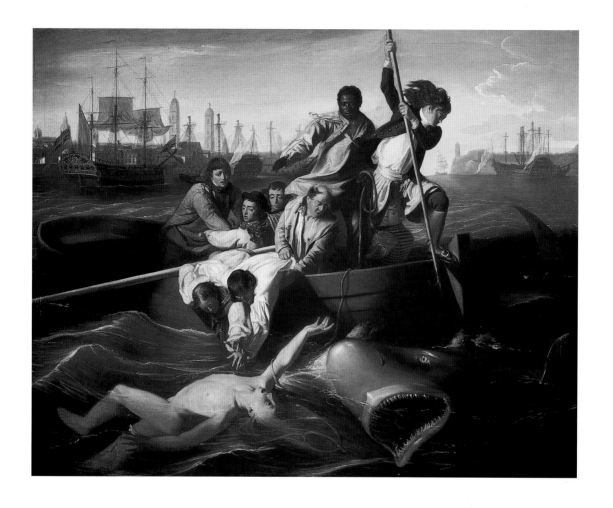

Although there is a lovely seascape in the background, the artist encloses all the action of the scene in a triangle—not one that is drawn, but one that you can construct with your eyes. As if you were connecting dots with a pencil, trace your finger from the top of the harpoon, down to Watson's foot, across to the very back of the shark's mouth, and back to where you started. Now look back through the pictures you've already seen. There is another one that uses this triangular trick to draw your eye to the action. Which one is it?

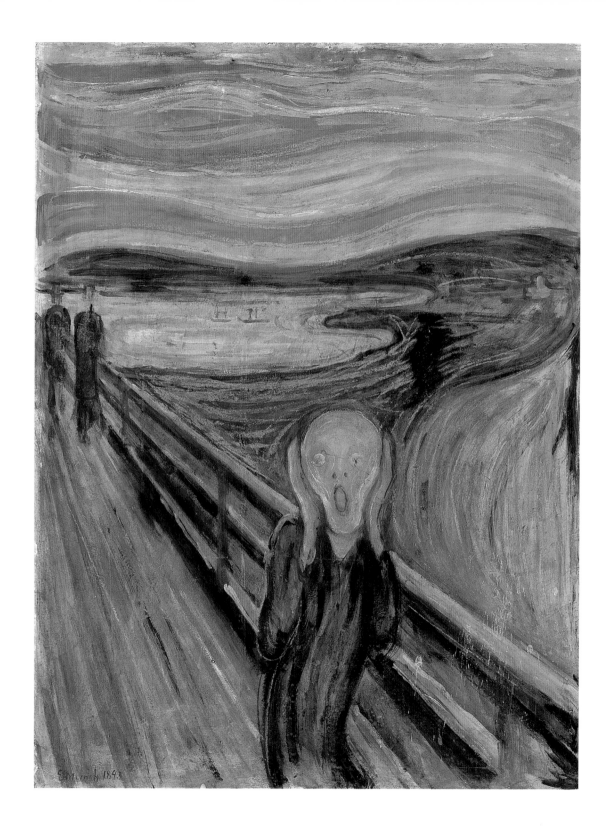

THE SCREAM

by Edvard Munch

In this very famous picture, a deeply frightened person stands on a bridge, alone except for some shadowy figures in the background. Why do you think the artist made this person look so distorted? He is screaming at something that the artist does not want you to see. What do you think it is? Why do you think the artist chose to leave out the thing that is terrifying this unlucky person? If this picture were a movie, what do you think would happen next?

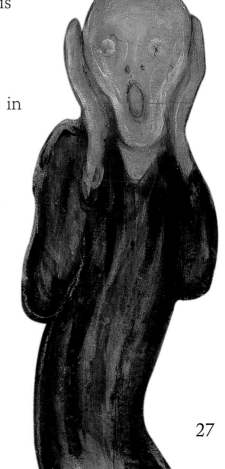

Although the bridge and the people in the background are painted with very straight lines, the rest of the picture swirls with curving lines of paint that create a feeling of creepy unrest, as if, for this very scared person, the world has lost its balance. Even his body swerves and sways. Why do you think the artist painted him this way?

MARRIAGE OF GIOVANNI ARNOLFINI AND GIOVANNA CENAMI

by Jan van Eyck

Of all feelings that exist, perhaps the most precious one is love. Just try to imagine your life without it, and you'll realize how important it is. In this wedding portrait painted over five hundred years ago, the artist captures a glimpse of love that is dignified and serious. The couple poses in their home, with hands joined together in matrimony. This display of affection seems very subtle compared with how people today may show their love for each other. What other quiet signs of love do you see?

In addition to showing the love between these newlyweds, the artist takes you into their home to show you aspects of their daily lives. He includes many details that help give the picture a realistic quality, such as the fur of the man's cloak and the folds of the lady's dress. Even the mirror on the wall holds a detail that you might not notice right away. Look carefully into the glass. What do you see?

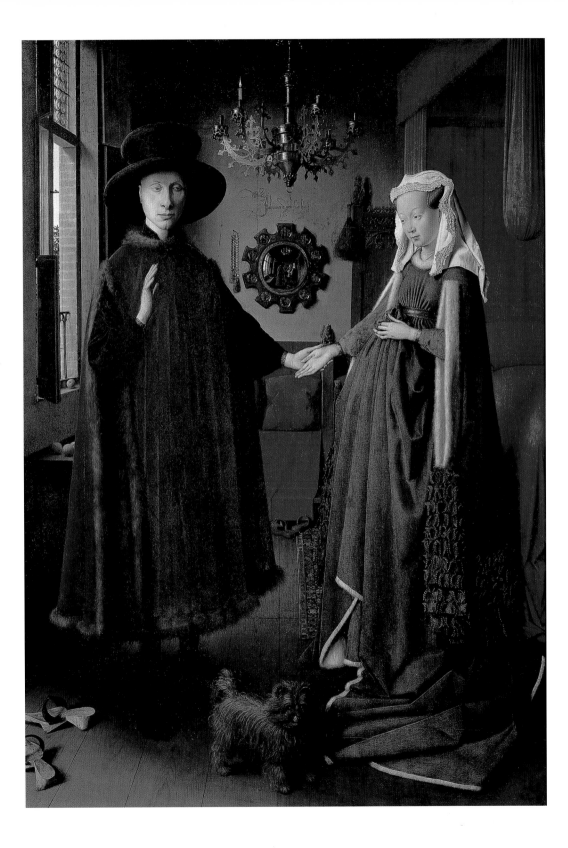

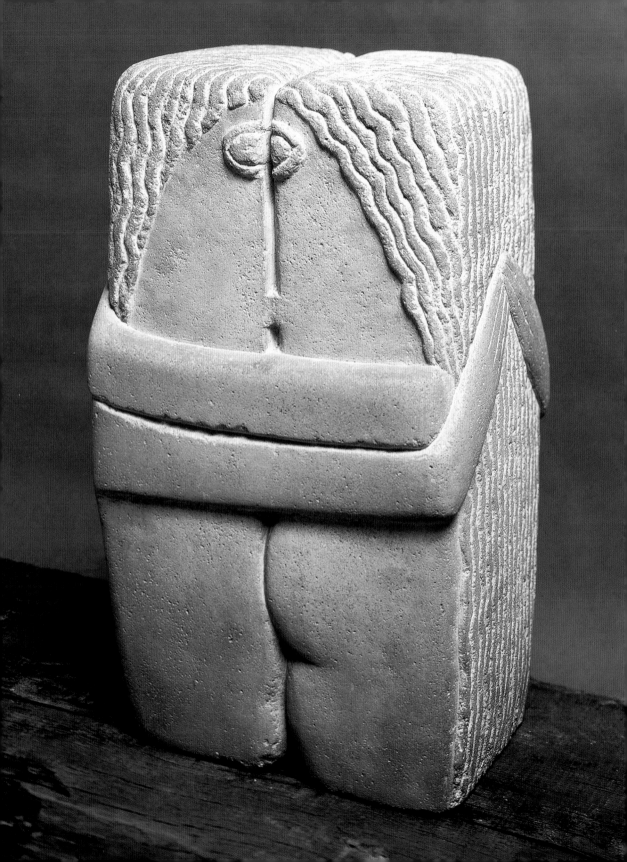

THE KISS

by Constantin Brancusi

Very few things express love more sweetly than a kiss. In this sculpture, the artist created the figures of two people literally locked in a loving embrace. As they kiss, they gaze at each other with wide-open eyes. If you were to come upon them, do you think they would notice you?

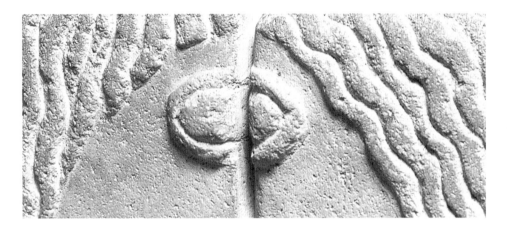

From a single, rectangular block of stone, the artist carved two separate yet intertwined figures. With simple lines and shapes the couple seems to emerge from the block. What other geometric shapes can you find? Now trace your finger along the lines of their hair and the outlines of their bodies. Very few of the lines are straight, and these wavy or curving lines give the sculpture a feeling of movement and texture. Look back through all the artworks in this book. Which ones use lines in this way?

31

UNDER THE HORSE CHESTNUT TREE

by Mary Cassatt

The bond that exists between mother and child is like no other. The artist who made this color print captured the love between this mother and her baby in a very simple way. Starting with the baby's face, let your eyes travel down the child's arm to the mother's eyes, down the mother's back, and up her left arm until you reach the baby again. This circle of warmth and affection forms a loop that your eyes want to experience over and over again. Why do you think the artist composed her picture in this way?

Like the picture *Lemon and His Wife's Ghost,* this picture has just a few colors and nothing in the background. But instead of black and white, here the artist used cool greens and blues, and warm, sunny yellows. What do these colors call to mind? How do they help create a loving atmosphere in the picture?

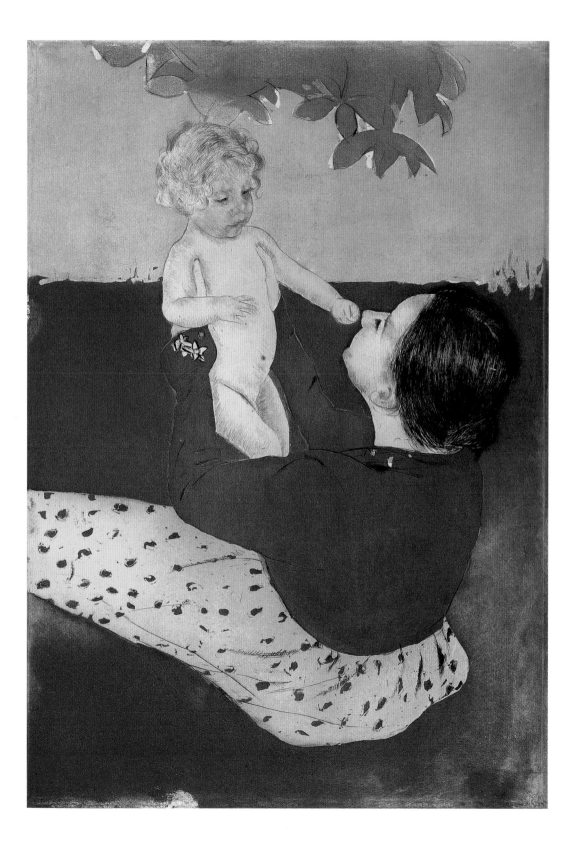

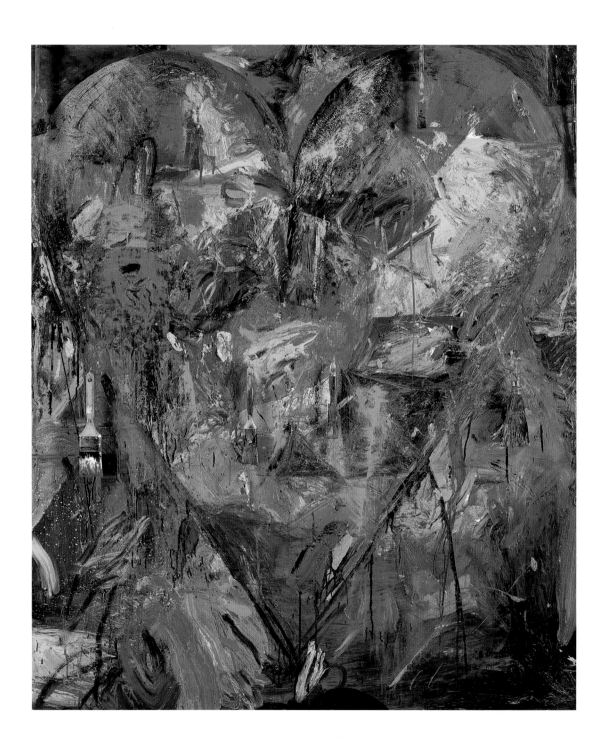

A REDHEADED FOOL

by Jim Dine

There are many symbols that represent love: red roses, cupids slinging arrows, and of course, hearts! In this picture, a huge, multicolored heart pulsates as if it's ready to burst. How has the artist used paint to convey a feeling of movement and energy? It's clear that the artist is having lots of fun with paint, and he even attached paint-covered brushes to the canvas. How many can you find? How does this playfulness capture the feeling of love?

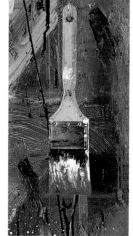

Just like a rainbow that consists of many colors, the human heart holds many feelings, each one colored in a different way. How many colors does this heart contain? This picture is called *A Redheaded Fool.* Sometimes people who are in love are called "fools for love." How do you think the artist has shown what such people are feeling? When you look at this picture, what is your heart feeling?

Now that you know how some artists show feelings, try creating a work of art that expresses your own emotions.

NOTE TO PARENTS
AND TEACHERS

As an elementary school teacher I had the opportunity to show my students many examples of great art. I was always amazed by their enthusiastic responses to the colors, shapes, subjects, and fascinating stories of the artists' lives. It wasn't uncommon for us to spend an entire class period looking at and talking about just one work of art. By asking challenging questions, I prompted the children to examine and think very carefully about the art, and then quite naturally they would begin to ask all sorts of interesting questions of their own. These experiences inspired me to write this book and the other volumes in the *How Artists See* series.

How Artists See is designed to teach children about the world by looking at art, and about art by looking at the world through the eyes of great artists. The books encourage children to look critically, answer—and ask—thought-provoking questions, and form an appreciation and understanding of an artist's vision. Each book is devoted to a single subject so that children can see how different artists have approached and treated the same theme, and begin to understand the importance of individual style.

Because I believe that children learn most successfully in an atmosphere of exploration and discovery, I've included questions that encourage them to formulate ideas and responses for them-

selves. And because people's reactions to art are based on their own personal aesthetic, most of the questions are open-ended and have more than one answer. If you're reading aloud to your children or students, give them ample time to look at each work and form their own opinions; it certainly is not necessary to read the whole book in one sitting. Like a good book or movie, art can be enjoyed over and over again, each time with the possibility of revealing something that wasn't seen before.

You may notice that dates and other historical information are not included in the main text. I purposely omitted this information in order to focus on the art and those aspects of the world it illustrates. For children who want to learn more about the artists whose works appear in the book, short biographies are provided at the end, along with suggestions for further reading and a list of museums where you can see additional works by each artist.

After reading *How Artists See Feelings,* children can do a wide variety of related activities to extend and reinforce all that they've learned. In addition to the simple activities I've suggested throughout the main text, they can play charades, make an "emotion collage" using magazine clippings of pictures that depict feelings, or draw a self-portrait that conveys an emotion. Since the examples shown here are just a tiny fraction of the great works of art that feature feelings as their subject, children can go on a scavenger hunt through museums, your local library, or the Internet to find other images of feelings.

I hope that you and your children or students will enjoy reading and rereading this book and, by looking at many styles of art, discover how artists share with us their unique ways of seeing and depicting our world.

(in order of appearance)

If you'd like to know more about the artists in this book, here's some information to get you started:

DESIDERIO DA SETTIGNANO (c. 1429–1464), *pp. 4–5*

This Italian sculptor was born near the hillside village of Settignano, near Florence. Today he is known by his birthplace and is called Desiderio da Settignano (pronounced *dez-ih-DAHR-ee-o dah SETT-i-NYAH-no).* Da Settignano lived and worked in the early part of the period known as the Italian Renaissance, a time of great artistic growth and creativity in Europe. In his early twenties, he joined an organization of stonecutters, called a guild, and probably apprenticed in the workshop of the sculptor Donatello, one of the greatest artists of the day. After his apprenticeship he opened a studio with his brother and produced elegantly carved marble sculptures of children and Madonnas. Today, Desiderio da Settignano is famous for his ability to express human emotions in stone.

PIERRE-AUGUSTE RENOIR (1841–1919), *pp. 6–7*

Pierre-Auguste Renoir (pronounced *ren-WAH*) was born in a small town in France but grew up in bustling Paris. As a boy, he worked in studios for decorative arts painting pretty scenes on household items, such as plates, fans, and screens. In his early twenties Renoir enrolled in art school, where he met other young students who would change the way people think about painting. Along with friend Claude Monet, Renoir formed a group of painters known as the Impressionists, who painted scenes that show light and color in a natural way. In 1874, they and others exhibited their work in the first Impressionist exhibition, which was criticized by many people for its new and untraditional ways of looking at the world. Because Renoir didn't mix his colors or use dark outlines, his pictures of women and scenes of people having fun outdoors look soft and fuzzy. He once said, "Why shouldn't art be pretty? There are enough unpleasant things in the world." Today, Renoir is considered one of the founders of modern art.

JEAN-HONORÉ FRAGONARD (1732–1806), *pp. 8–9*

This French artist began painting when he was eighteen years old. He studied with two "master painters" who would become famous themselves: Jean-Baptiste-Siméon Chardin (see *How Artists See Play*) and François Boucher. He later became a court painter to kings Louis XV and XVI. In 1752 he won the coveted Prix de Rome, a prize reserved for the most gifted artists. Working in the Rococo style, known for its elaborate detail, Fragonard (pronounced *frag-oh-NAHR*) painted mostly playful scenes of the upper class set in lush gardens and elegant rooms. During the French Revolution, however, Fragonard's paintings were seen as old-fashioned and went out of style. Because he was associated with the king who was overthrown, Fragonard fled the country in fear for his life, and died a poor, old man. Today his paintings are considered

masterpieces and hang in the world's most important museums.

AARON DOUGLAS
(1899–1979), *pp. 10–11*

African-American painter Aaron Douglas once said, "I refuse to compromise and see blacks as anything less than a proud and majestic people." Douglas was born and raised in Kansas, and then moved to Nebraska to attend college. After graduation he worked as a high school art teacher before moving to New York City, where he would become a major artist of the Harlem Renaissance, a period of great artistic achievement in the early twentieth century. It was during this time that Douglas began to paint works about the history and modern lives of African Americans. He produced powerful murals for libraries and other public spaces, and created illustrations for books and journals. Douglas headed the art department at Fisk University for nearly thirty years until he retired in 1966.

MASACCIO
(1401–1428), *pp. 12–13*

Considered one of the founders of the Italian Renaissance, the painter known as Masaccio (pronounced *ma-SAH-cho*) lived and worked six hundred years ago, but many of the things he invented during his short lifetime would influence how art would be made right up through the twentieth century. Little is known about Masaccio's early life, except that he moved to Florence, Italy, at a young age and began working with much older, more experienced artists. Masaccio is credited with being the first artist to use perspective—an artistic technique that makes flat, two-dimensional images appear three-dimensional. He also created the illusion of light in his painting with its play of highlights and shadows. These two innovations, which made his paintings appear more realistic, were seen as revolutionary in Masaccio's time and are still considered important today. His series of frescoes in the Brancacci Chapel in Florence, which include *The Expulsion,* are considered his greatest works.

PABLO PICASSO
(1881–1974), *pp. 14–15*

Picasso (pronounced *pea-KAH-so*) was born in Spain, but for most of his life he lived and painted in France. Picasso began to draw as a young boy, and his family noticed and encouraged his talents. While in art school, Picasso amazed his teachers with his drawing abilities, which resembled works of "Old Master" painters such as Rembrandt and Velazquez. At age nineteen, he moved to France, where he would help change the course of art. Throughout his long life he explored many different styles of art, but he is perhaps best known for a style called Cubism, in which the subject seems to be broken into many shapes and is seen from many angles at once. Picasso lived to be an old man, and his hundreds of paintings, drawings, sculptures, and ceramics can be seen in museums all over the world. Many people consider him the most important artist of the twentieth century and one of the greatest painters in history.

KÄTHE KOLLWITZ
(1867–1945), *pp. 16–17*

Scenes of poverty, protests, mothers and children, and death characterize the work of German printmaker and sculptor Käthe Kollwitz (pronounced *COAL-vitz*). At age fourteen, she began her art studies. Kollwitz's father supported her desire to become an artist, and even encouraged it.

She later said, "From my childhood on, my father had expressly wished me to be trained as an artist, and he was sure there would be no great obstacles to my becoming one." Although she did become an artist, personal losses, such as the death of a son and grandson and harassment by the Nazis during World War II, made her life extremely difficult. Despite these hardships, Kollwitz managed to create timeless works of great power.

ROY LICHTENSTEIN (1923–1997), *pp. 18–19*

This American painter studied art the Art Students League in New York City, a school attended by many well-known modern artists. After that he left New York to attend graduate school and become an art teacher. In his first one-man exhibition in 1962, his huge canvases of comic-book images made him an overnight sensation and began the style known as Pop Art. He and other Pop artists painted pictures of popular things that people recognize from everyday life, and of their subject matter Lichtenstein (pronounced *LIHK-ten-shtine*) once said, "We wanted to paint pictures so outrageous and ugly that no one would buy them." But people did buy them, and Lichtenstein became one of the most successful artists of the twentieth century. He lived and worked most of his life in and around New York City, where he died in 1997.

SHUNBAISAI HOKUEI (ACTIVE C. 1827–1837), *pp. 20–21*

This master woodblock printmaker from the Osaka region of Japan was known for his skilled use of cutting tools and printing techniques. His most famous prints are of actors performing alone on a dark stage. Because he often portrayed an actor during a particularly dramatic moment in a play, his works are filled with tension, suspense, and mystery. Hokuei (pronounced *HOE-kie*) worked in the *Ukiyo-e* tradition, which was popular from the 1740s to the 1890s. Common Ukiyo-e subjects are actors on stage and in portraits, beautiful women and fashions, popular customs, landscapes, and scenes from daily life. Often on the prints are Japanese characters showing the artist's signature, the title of the work, and sometimes even a review by an art critic. Hokuei and other Ukiyo-e artists influenced the French Impressionists and the American painter and printmaker Mary Cassatt (look back at *Under the Horse Chestnut Tree*).

JOHN STEUART CURRY (1897–1946), *pp. 22–23*

This American painter was born in Kansas and later became known as a Regionalist painter because his works depict the midwestern region of the United States. Curry (pronounced *KUH-ree*) began studying art after high school, and spent a short time in Paris, where he studied the works of the "Old Masters." He then moved to New York City, where he taught art and made illustrations for books and magazines. Although living in the eastern United States, his paintings were set mostly in the Midwest. The lives of farmers, the land they worked, and the hardships they faced became the subjects of many of Curry's paintings during his short, twenty-year career. One of his final projects before his death at the age of forty-nine was a mural of the history of Kansas. Today Curry's paintings remain symbols of the American Midwest of the 1930s.

JOHN SINGLETON COPLEY (1738–1815), *pp. 24–25*

Recognized as the leading painter from the colonial period, this American artist is famous for his portraits and historical scenes. He often painted portraits of people, such as Paul Revere, in their everyday surroundings and included objects used in their daily lives. In 1774 Copley left the American colonies for Europe, where he traveled throughout Italy and England and began exhibiting his work. In London Copley painted the famous *Watson and the Shark,* a dramatic scene based on a real event (see this picture on pages 24–25. The man was rescued and survived). Copley lived the rest of his life in England, until he died at the age of seventy-seven.

EDVARD MUNCH (1863–1944), *pp. 26–27*

Born in Norway, Edvard Munch (pronounced *MOONK*) is best known for pictures that portray sadness, illness, fear, and death. He began painting as a teenager, and he won a government grant that allowed him to study art in Paris, then the center of the art world. His work helped develop the style of art known as Expressionism, in which painters made pictures about their deepest feelings. Due to a mental illness, Munch was placed in a hospital in his home country and died the following year. This extremely original artist worked in many mediums, including etchings and lithographs, yet he is known mostly for his paintings, such as *The Scream,* seen on pages 26–27.

JAN VAN EYCK (C. 1390–1441), *pp. 28–29*

Very little is known about the life of Jan van Eyck (pronounced *van-IKE),* but we do know that he worked as a court painter for Philip the Good, Duke of Burgundy, and records show that he often accompanied the ruler on trips abroad. The style of this Old Master Flemish painter is marked by a striking ability to show people, places, and things as they really look. He was one of the first artists ever to use oil paint, and some people believe that he may have even invented it. Many artists who lived long after van Eyck learned important lessons by looking at his paintings, such as how to show light and shadow and how to capture a person's personality in a portrait. This talented artist worked for just seven years, and only twenty works by his hand exist today.

CONSTANTIN BRANCUSI (1876–1957), *pp. 30–31*

This sculptor was born in Romania, and at the age of ten Brancusi (pronounced *bran-COOSH)* quit school and worked as a shepherd. Later, he trained in a woodworking shop, where he learned to carve, a skill that he would use for the rest of his life. After attending art school, where he studied sculpture, he moved to Paris and worked for a brief time for the respected sculptor Auguste Rodin. Although many sculptors would have stayed with this experienced artist, Brancusi left the job, saying, "Nothing grows under the shade of great trees." Working alone in his studio, Brancusi strived to make his sculptures as simple as possible, basing them on natural forms, such as the egg and the cylinder. He once

said, "One arrives at simplicity . . . as one approaches the real meaning of things." Brancusi went on to become one of the most original sculptors of the twentieth century, creating elegant works inspired by nature, and using a variety of materials, such as wood, marble, and metal.

MARY CASSATT (1844–1926), *pp. 32-33*

Born into a wealthy family, the American painter Mary Cassatt (pronounced *kuh-SAHT*) traveled throughout Europe when she was young. On these trips she was exposed to the works of the European masters and decided to become a professional artist. She studied art at the Pennsylvania Academy of Fine Arts in Philadelphia and later in Italy and Paris, where she moved in 1874. There she met Impressionist artist Edgar Degas. They quickly became friends and soon Cassatt began painting in a style similar to Degas's and the other Impressionists', and she even exhibited her own work with theirs on many occasions. She is best known for her portraits of mothers with their children and of women doing everyday activities, such as sealing a let-ter or adjusting a veil. Besides being a painter, she was also a printmaker, and many of her prints were influenced by the Japanese woodcuts so popular in late-nineteenth-century Paris (see *Lemon and his Wife's Ghost,* pages 20–21).

JIM DINE (B. 1935), *pp. 34–35*

Hearts, skulls, birds, bathrobes, and tools are just some of the things that American artist Jim Dine chooses as subjects for his paintings, drawings, and sculptures. Dine began his professional career in New York City in the early 1960s where he helped form the Pop Art style, in which common images such as comic books and soup cans became subjects of artwork (look back at *Drowning Girl* on pages 18–19). Dine was different from the other Pop artists because his subjects were based on his personal memories and emotions. Of the heart, a subject he has used over and over again, Dine said, "[It is] a sign that one can care, that there is a constant presence of feeling." Famous for his excellent drawing skills, the work of Jim Dine can be found in museums all over the world.

SUGGESTIONS FOR FURTHER READING

The following children's titles are excellent sources for learning more about the artists profiled in this book:

FOR EARLY READERS (AGES 4–7)

Hart, Tony. Illustrated by Susan Hellard. *Picasso.* Famous Children series. Hauppauge, New York: Barrons Juveniles, 1994.
What was the twentieth century's most famous artist like as a kid? The childhood of Picasso is the subject of this engaging book.

Morrison, Taylor. *Antonio's Apprenticeship: Painting a Fresco in Renaissance Italy.* New York: Holiday House, 1996.
A young boy's apprenticeship in a Florentine workshop is the setting for this story as he learns the art of fresco painting.

Sweeney, Joan. Illustrated by Jennifer Heyd Wharton. *Suzette and the Puppy: A Story About Mary Cassatt.* Hauppauge, New York: Barrons Juveniles, 1994.
The young French girl in a famous Cassatt painting meets and models for the American Impressionist painter.

Venezia, Mike. *Pierre-Auguste Renoir.* Getting to Know the World's Greatest Artists series. Chicago: Children's Press, 1996.
Impressionist painter Renoir is the subject of this volume in the popular series that combines factual information, humorous illustrations, and color reproductions to introduce young children to art history.

FOR INTERMEDIATE READERS (AGES 8–10)

Bolton, Linda. *Art Revolutions: Pop Art.* New York: Peter Bedrick Books, 2000.
This colorful reference book takes children on a wild journey through the world of Pop Art.

Lewis, Zoe. Illustrated by Dan Burr and Rich Grote. *Keisha Discovers Harlem.* Keisha's Adventures series. New York: Magic Attic Press, 1998.
Keisha goes back in time to discover the artists, poets, and achievements of the Harlem Renaissance.

Pfleger, Susanne and Christopher Wynne. *A Day with Picasso.* Adventures in Art series. New York: Prestel USA, 1999.
This book invites you to spend a day with the twentieth century's most renowned artist and learn why he's considered to be one of the greatest artists of all time.

Skira-Venturi, Rosabianca. *A Weekend with Renoir.* New York: Rizzoli, 1996.
This informative and clever book takes you back in time to meet the French Impressionist painter as you learn about his life and work.

FOR ADVANCED READERS (AGES 11+)

Jacques, Geoffrey. *Free Within Ourselves: The Harlem Renaissance.* African-American Experience series. Franklin Watts, Inc., 1996.
The art and culture of one of the most creative periods in American history is the focus of this informative reference book.

Meyer, Susan E. *Mary Cassatt.* Abrams First Impression Book series. New York: Harry N. Abrams, 1990.
The life and work of American painter Mary Cassatt is the subject of this informative volume.

Selfridge, John W. *Pablo Picasso.* Hispanics of Achievement series. New York: Chelsea House, 1993.
This biography provides an excellent introduction to the Spanish painter who helped shape the course of art in the twentieth century.

Spence, David. *Picasso: Breaking the Rules.* Hauppauge, New York: Barrons Educational Series, 1997.
Advanced readers will learn how Picasso's groundbreaking style influenced how art was made in the twentieth century.

WHERE TO SEE THE ARTISTS' WORK

CONSTANTIN BRANCUSI

- The Art Institute of Chicago
- Centre National d'Art et de Culture Georges Pompidou, Paris
- John Paul Getty Museum, Los Angeles, California
- Dallas Museum of Art
- Fine Arts Museums of San Francisco
- Museum of Modern Art, New York
- Museum of Modern Art Ludwig Foundation, Vienna
- National Museum of Art of Romania
- Portland Art Museum, Oregon
- Sheldon Memorial Museum and Sculpture Garden, Lincoln, Nebraska
- http://www.artcyclopedia.com/artists/brancusi_constantin.html

MARY CASSATT

- The Art Institute of Chicago
- Cleveland Museum of Art
- Dallas Museum of Art
- The Metropolitan Museum of Art, New York
- Musée d'Orsay, Paris
- National Gallery of Art, Washington, D.C.
- Nelson-Atkins Museum of Art, Kansas City, Missouri
- Philadelphia Museum of Art
- Pushkin Museum of Art, Moscow
- http://www.metmuseum.org/explore/cassatt/html/index.html
- http://www.ibiblio.org/wm/paint/auth/cassatt/

JOHN SINGLETON COPLEY

- Fogg Art Museum, Cambridge, Massachusetts
- The Metropolitan Museum of Art, New York
- Minneapolis Institute of Arts, Minneapolis, Minnesota
- Museum of Art at the Rhode Island School of Design, Providence
- Museum of Fine Arts, Boston
- National Gallery of Art, Washington, D.C.
- Tate Gallery, London
- The Toledo Museum of Art, Toledo, Ohio
- Yale University Art Gallery, New Haven, Connecticut
- http://cgfa.kelloggcreek.com/copley/index.html

JOHN STEUART CURRY

- Butler Institute of American Art, Youngstown, Ohio
- Fine Arts Museums of San Francisco
- The Metropolitan Museum of Art, New York
- Museum of Fine Arts, Brigham Young University, Provo, Utah
- National Museum of American Art, Smithsonian Institution, Washington, D.C.
- Nevada Museum of Art, Reno, Nevada
- Sheldon Memorial Art Gallery and Sculpture Garden, University of Nebraska, Lincoln
- Whitney Museum of American Art, New York
- http://www.artcyclopedia.com/artists/curry_john_steuart.html

JIM DINE

- Albright-Knox Art Gallery, Buffalo, New York
- Art Gallery of Ontario, Toronto, Canada
- Dallas Museum of Art, Dallas, Texas
- Hirshhorn Museum and Sculpture Garden, Smithsonian Institution, Washington, D.C.
- Israel Museum, Jerusalem
- Museum of Modern Art, New York
- Orange County Museum of Art, Newport Beach, California
- Rose Art Museum, Brandeis University, Waltham, Massachusetts
- Stedelijk Museum, Amsterdam, Netherlands
- Walker Art Center, Minneapolis, Minnesota
- http://www.guggenheim.org/exhibitions/past_exhibitions/dine/dine_bottom2.html
- http://paceprints.com/contemporary/dine/dine-fiveshells193.127.asp

AARON DOUGLAS

- The Art Institute of Chicago
- Corcoran Gallery of Art, Washington, D.C.
- Carl Van Vechen Gallery of Fine Arts, Fisk University, Nashville, Tennessee
- Fisk University Library, Nashville, Tennessee
- New York City Public Library, 135th Street Branch
- The Art Gallery at the University of Maryland, College Park
- Sheldon Memorial Art Gallery and Sculpture Garden, University of Nebraska, Lincoln
- http://www.artcyclopedia.com/artists/douglas_aaron.html
- http://www.ops.org/wal/douglasweb/ad_activity.html

JAN VAN EYCK

- Detroit Institute of Arts, Michigan
- The Frick Collection, New York
- Groeninge Museum, Belgium
- Kunsthistoriches Museum, Vienna
- Louvre Museum, Paris
- The Metropolitan Museum of Art, New York
- Museum of Art History, Vienna
- National Gallery, London
- National Gallery of Art, Washington, D.C.
- Saint Bravo, Ghent, Belgium
- Thyssen-Bornemisza Museum, Madrid
- http://www.artcyclopedia.com/artists/eyck_jan_van.html

JEAN-HONORÉ FRAGONARD

- Fine Arts Museums of San Francisco
- The Frick Collection, New York
- John Paul Getty Museum, Los Angeles
- Kimbell Art Museum, Fort Worth, Texas
- Louvre Museum, Paris
- The Metropolitan Museum of Art, New York
- Museu de Arte de Sao Paulo, Brazil
- National Gallery, London
- National Gallery of Art, Washington, D.C.
- Norton Simon Museum, Pasadena, California
- State Hermitage Museum, Saint Petersburg, Russia
- Wallace Collection, London
- http://www.artcyclopedia.com/artists/fragonard_jean-honore.html

HOKUEI *and Japanese Prints in the Ukiyo-e Style*

- Freer Gallery of Art, Smithsonian Institution, Washington, D.C.
- Fine Arts Museums of San Francisco
- The Japan Ukiyo-e Museum, Matsumoto

- The Metropolitan Museum of Art, New York
- Museum of Fine Arts, Boston
- Springfield Museum of Fine Art, Springfield, Massachusetts
- http://spectacle.berkeley.edu/~fiorillo/4hokuei.htnl
- http://www.thinker.org

KÄTHE KOLLWITZ

- The Art Gallery at the University of Maryland, College Park
- Bayly Art Museum, Charlottesville, Virginia
- Davison Art Center, Middletown, Connecticut
- Fine Arts Museums of San Francisco
- Käthe Kollwitz Museum, Berlin
- MacKenzie Art Gallery, Saskatchewan, Canada
- National Museum of Women in the Arts, Washington, D.C.
- Wilhelm Lehmbruck Museum, Germany
- http://www.artcyclopedia.com/artists/kollwitz_kathe.html

ROY LICHTENSTEIN

- Guild Hall Museum, East Hampton, New York
- Solomon R. Guggenheim Museum, New York
- Florida State University Gallery and Museum, Tallahassee
- Museum of Modern Art, New York
- Plattsburgh Art Museum, Plattsburgh, New York
- Stanford University Museum of Art and T.W. Stanford Art Gallery, Stanford, California
- Whitney Museum of American Art, New York
- http://www.absolutearts.org/masters/names/Lichtenstein_Roy.html
- http://www.lichtensteinfoundation.org/

MASACCIO

- Brancacci Chapel, Florence, Italy
- Isabella Stewart Gardener Museum, Boston
- John Paul Getty Museum, Los Angeles
- Museo di Capodimonte, Naples, Italy
- Museo di San Matteo, Pisa, Italy
- National Gallery, London
- Santa Maria del Carmine, Florence, Italy
- Santa Maria Novella, Florence, Italy
- Uffizi, Florence, Italy
- http://cgfa.kelloggcreek.com/masaccio/index.html

EDVARD MUNCH

- Billedgalleri, Bergen, Norway
- Munch Museum, Oslo, Norway
- National Gallery, Berlin, Germany
- National Gallery, Oslo, Norway
- Rasmus Meyer Collection, Bergen, Norway
- http://cgfa.kelloggcreek.com/munch/index.html

PABLO PICASSO

- Albright-Knox Art Gallery, Buffalo, New York
- Art Gallery of Ontario, Toronto, Canada
- The Art Institute of Chicago
- Dallas Museum of Art, Texas
- Solomon R. Guggenheim Museum, New York
- Los Angeles County Museum of Art
- McNay Art Museum, San Antonio
- The Metropolitan Museum of Art, New York
- Musée Picasso, Paris
- Museum of Modern Art, New York
- Philadelphia Museum of Art
- Phoenix Art Museum, Arizona
- The Picasso Museum, Antibes, France
- http://www.tamu.edu/mocl/picasso/emblem.html
- http://home.xnet.com/~stanko/paint.htm

PIERRE-AUGUSTE RENOIR

- Arkansas Art Center, Little Rock
- Dallas Museum of Art
- Charles and Emma Frye Art Museum, Seattle
- Solomon R. Guggenheim Museum, New York
- The Metropolitan Museum of Art, New York
- Musée d'Orsay, Paris
- National Gallery of Art, Washington, D.C.
- Philadelphia Museum of Art
- The Phillips Collection, Washington, D.C.
- Norton Simon Museum of Art, Pasadena, California
- http://www.metmuseumorg/collections/result.asp?Artist=renoir
- http://www.nga-gov/cgi-bin/psearch

DESIDERIO DA SETTIGNANO

- Bargello, Florence
- Kunsthistorisches Museum, Vienna
- Louvre Museum, Paris
- National Gallery of Art, Washington, D.C.
- Pazzi Chapel, Santa Croce, Florence, Italy
- Philadelphia Museum of Art

CREDITS *(listed in order of appearance)*